Esther Nissard for B29 Produ
Neil McPherson for the Finbc

The World Premiere

KHADIJA IS 18
by Shamser Sinha

Supported using public funding by
**ARTS COUNCIL
ENGLAND**
LOTTERY FUNDED

FINBOROUGH | THEATRE

First performance at the Finborough Theatre: Tuesday, 30 October 2012

KHADIJA IS 18

by Shamser Sinha

Cast in order of speaking

Ade	**Victor Alli**
Khadija	**Aysha Kala**
Liza	**Katherine Rose Morley**
Sam	**Damson Idris**
Joanna	**Sioned Jones**

The action takes place in Hackney, 2012.

The performance lasts approximately 70 minutes.

There will be no interval.

Director	**Tim Stark**
Designer	**Fly Davis**
Costume Designer	**Sarah Dicks**
Lighting Designer	**Dani Bish**
Sound Designer	**Mark Dunne**
Stage Manager	**Linda Hapgood**
Assistant Director	**Dan Pick**
Producer	**Esther Nissard**
Assistant Producer	**Luke Holbrook**
Press Representative	**James Lever for Target Live**
Press, PR, Marketing and Design	**Target Live**
Set Construction	**RK-Resource**
Rehearsal Space	**Identity Drama School**
Production Photography	**Robert Workman**

Our patrons are respectfully reminded that, in this intimate theatre, any noise such as rustling programmes, talking or the ringing of mobile phones may distract the actors and your fellow audience-members.

We regret there is no admittance or re-admittance to the auditorium whilst the performance is in progress.

Victor Alli | Ade
Trained at the Identity Drama School and the Brit School.
Theatre includes *Fugee* (National Theatre New Connections) and *Blackout* (Watford Palace Theatre).
Film includes *Gone Too Far* and *Ghost Class*.

Damson Idris | Sam
Trained at the Identity Drama School.
Theatre includes *Pandora's Box* (Arcola Theatre)
Film includes *Attack The Block*, *51 Degrees* and *My Brother The Devil*.
Television includes *Miranda.*

Aysha Kala | Khadija
Trained at the Royal Welsh College of Music and Drama.
Theatre includes *Much Ado About Nothing* (Royal Shakespeare Company and West End).
Film includes *Jadoo*.
Television includes playing series regular, Sita, in *Shameless*.

Katherine Rose Morley | Liza
Trained at the Guildhall School of Music and Drama.
Theatre whilst training included *Chaplin*, *Lysistrata*, *The Life and Adventures of Nicholas Nickleby*, *Jenufa*, *Think Only This of Me*, *The Women*, *Antony and Cleopatra*, *The Lucky Stiff*, *Agamemnon*, *The False Count*, *The Permanent Way*, *Three Sisters* and *The Country*.

Sioned Jones | Joanna
At the Finborough Theatre, Sioned appeared in *The Illustrious Corpse* (2004).
Trained at Exeter University and the Webber Douglas Academy of Dramatic Art.
Theatre includes *13*, *Women Beware Women*, *All's Well That Ends Well*, *Oedipus* and *Never So Good* (National Theatre), *Tolstoy* (Aldwych Theatre and National Tour), *Glorious!* (Duchess Theatre), *The Letter* (Wyndhams Theatre and National Tour), *Shadowlands* (Wyndham's and Novello Theatres and National Tour), *Love on the Tracks* (Watermill Theatre,

Newbury), *The Giraffe, the Pelly and Me* (Birmingham Old Rep), *Monumental* (Grid Iron at the Citizens Theatre, Glasgow), *Twelfth Night* (Palace Theatre, Westcliff-on-Sea, and Cambridge Arts Theatre), *Romeo and Juliet* (National Tour), *The Wild Party, The Windmill, The Cheeky Chappie, Big Voice Cabaret, Pippin, Have a Nice Life!* and *Pub* (Union Theatre), *Wolf!* (New Wolsey Theatre, Ipswich), *Golden Opportunities* (Croydon Warehouse), *People Show 104, Vision of Pride* (Theatre 503), *Conor Mitchell's Anthology* (St Paul's) and *Old 100th* (Drury Lane Salon). Other Theatre includes producing *Mme Charlotte-Ann Arcati's Christmas Presence, Gypsy – Once in a Blue Moon* and *Be My Baby* (Union Theatre), directing *Lie Back In Anger* (Union Theatre) and *Basket* (Edinburgh Festival), and writing *The Juror* and *Christmas Presence* (Union Theatre), co-writing a musical, *Ovid's Transformations* (Waterfront Hall, Belfast) and a new play *Stoned* which is currently in development.

Film includes *Happy Now? Flamenco Fever* and *Cleanskins and Madharasapattinam*.

Television includes *Cadfael, The Bill* and *Family Affairs*.

Sioned is also an exhibited oil painter.

Shamser Sinha | Playwright

Playwright Shamser Sinha has been a writer on attachment at the Royal Court Theatre where he wrote *Storm*, and was commissioned by ANGLE as writer in residence to write *Chicken N'Chips*. He works as a lecturer in Sociology and Youth Studies, and has spent the past ten years doing research and youth work with young asylum seekers and vulnerable teenagers in London. Originally discovered via ANGLE Theatre's 'Call for Plays' campaign in East London, *Khadija is 18* was among 70 submissions they received from new writers. 50 of these plays were from first time writers, with 40 playwrights coming from a BAME background, and a remarkable 4 entries from non-English speakers. Shamser's play was one of three winners, and along with two other writers his script received a production-without-décor as part of *Triangle* at Hackney Empire. ANGLE won the 2009 Peter Brook Empty Space Award for their new writing work and for producing *Triangle* (Hackney Empire). This production of *Khadija is 18* marks Shamser's full-length professional debut.

Tim Stark | Director

Director Tim Stark is a winner of the John S. Cohen Directors Bursary at the National Theatre Studio and English Touring Theatre, a founding member of B29 Productions and Artistic Associate of ANGLE Theatre from 2009 to 2011. Tim was a Regional Director for National Theatre Connections, producing *Blackout* in the Olivier Theatre as part of National Theatre

Connections. Other directing includes *Once and Future Plays*, five short new plays by Philip Ridley, Mark Ravenhill, Dominic Francis, Judith Johnson and Nick Drake (Cactus Productions – Site Specific), *Kurt and Sid* which was nominated for the *WhatsOnStage* award for Best Off-West End Production (Trafalgar Studios), *The Last Pilgrim* which was shortlisted for the OffWestEnd Award for Best New Play (White Bear Theatre), *Road* (Royal and Derngate Theatre, Northampton) *Rafts and Dreams* and *Mayhem* (Royal Exchange Theatre, Manchester), *Festen* (Birmingham Rep and National Tour), *Edward Bond's Lear* (National Theatre Studio and Teatro Due International Theatre Festival), *Shadow Language* (Theatre 503),*Twisted* (Oval House), *Romeo and Juliet* (English Touring Theatre and Hong Kong Arts Festival), *The Boy Who Fell into a Book* (English Touring Theatre), *Julius Caesar* (Teatro Due International Theatre Festival and Verona Shakespeare Festival), *Cardiff East*, *Over Gardens Out*, *In the Blue* (Teatro Due International Theatre Festival), *Five Kinds of Silence*, *Bombing People* and *Signing Off* (Jermyn Street Theatre), *The Lunatic Queen* (Riverside Studios) and *Thick as Thieves* (Chelsea Theatre).

Fly Davis | Designer
At the Finborough Theatre, Fly designed *The Man* (2010) and its subsequent National Tour.
Trained at the Royal Academy of Dramatic Art and Motley.
Other theatre designs include *The Great British Country Fete* (Bush Theatre and National Tour), *The Silencer* (Pleasance Edinburgh), *Maximus and Audencia* (Bush Theatre), *Change* (Arcola Theatre), *Ignite 5 Old Vic New Voices* (Waterloo East Theatre), *'Av It* (Old Vic Tunnels), *The Wonderful World of Dissocia*, *Deathwatch* and *The Bear* (Drama Centre), *Bright Star* (Tabard Theatre), *When The Lilac Blooms* (Leicester Square Theatre), *Bloody Poetry* (White Bear Theatre), *Lovecat* (Theatre 503) and *Life Support the Indie Musical* (York Theatre Royal).
Opera designs for Tête à Tête and Size Zero Opera include *Innocence in the Asylum* and *The Sandman* (Riverside Studios and Singapore Tour) and *Dido and Aeneas* (Turner Sims Concert Hall, Southampton).
Work as Associate Designer includes *Disconnect* (Royal Court Theatre) *The Whisky Taster* (Bush Theatre), *Pictures at an Exhibition* with Philharmonia Orchestra (Royal Festival Hall) and *Playhouse Live: 'Hens'* (Riverside Studios and Sky Arts Television).
Fly is currently designing *Chavs* (Lyric Theatre, Hammersmith) and *What The Animals Say* (Camden Peoples Theatre, Hull Truck and Northern Stage for Greyscale).

Sarah Dicks | Costume Designer
Trained at The Arts University College Bournemouth.
She was the Winner of the Silver Podium award for Creative
Cultural Project (2012) and the Jean Hunnisett Award for Costume
Design (2011).
Costume designs include *Battle for the Winds* (Weymouth Olympic
Live Site), *The Caucus Race* (Merton Fields, Oxford) and *Under the
Concrete, Waiting* (Arts Educational Schools, London).

Dani Bish | Lighting Designer
Trained at Royal Welsh College of Music and Drama.
Dani's work has been recently exhibited as part of *Transformation
and Revelation*, an exhibition of National Theatre Designers which
has been seen in Cardiff, the Prague Quadrennial and at the
Victoria and Albert Museum. She also designed Opera'r Ddraig's
productions of *Acis and Galatea* and *Dido and Aeneas* (Gate
Theatre, Cardiff). Other lighting designs include *Elegy* by new
critically acclaimed theatre company Transport (Quarterhouse
in Folkestone, Edinburgh Festival and Theatre 503). Dani was
production technician and relighter for English Touring Opera's
Autumn Season 2011 which included productions of *Xerxes*, *Flavio*
and *The Fairy Queen*, as well as working with Welsh National
Opera's Max department. Dani regularly works as a lighting
technician at the National Theatre in the Olivier, Cottesloe and
Lyttleton Theatres.

Mark Dunne | Sound Designer
Theatre includes *Baggage* (Arts Theatre), *Bette and Joan* (National
Tour), *Behind The Iron Mask* (Duchess Theatre), *Lunch With Marlene
And Noël* (National Tour), *The Wedding* and *The Rime Of The Ancient
Mariner* (Festival Square, South Bank), *The Last Five Years* and
Pinter's People (Theatre Royal, Haymarket), *The Killing Of Sister
George* and *Bette and Joan* (Arts Theatre), *The House of Bernarda
Alba* (Union Theatre), *Kurt And Sid* and *Raindogs* (Trafalgar Studios),
Iceberg – Right Ahead (Upstairs At The Gatehouse), *The Bespoke
Overcoat*, *Mr Maugham At Home*, *Hetty Feinstein's Wedding
Anniversary*, *Tennessee Williams Triple Bill*, *G and I*, *Whatever
Happened To The Cotton Dress Girl,* and *Lunch With Marlene* (New
End Theatre, Hampstead), *Blondel* (Pleasance London), *Schemers
And Dreamers* (Ashcroft Theatre), *The Last Pilgrim* (White Bear
Theatre) and *Purlie* and *Burleigh Grimes* (Bridewell Theatre)
Concerts include *Notes From New York* (Duchess Theatre, Gala
Production at Trafalgar Studios and Donmar Warehouse), *A Spoonful
Of Stiles And Drewe* (Her Majesty's Theatre), *Jason Robert Brown
and the Caucasian Rhythm Kings* and *An Evening With Jason Robert
Brown* (New Players Theatre), *Christmas In New York* (Lyric Theatre

and Apollo Theatre), *A Little House Music* (Arts Theatre), *Grateful* (Cadogan Hall), *Lost In The Stars* (Queen Elizabeth Hall), *Frances Ruffelle – Beneath The Dress* (Madame JoJo's), *Anton Stephans* (Arts Club) and *Anthology* (Actor's Church).

Mark regularly works with international recording artists, most recently Westlife, Estelle and James Morrison.

Linda Hapgood | Stage Manager

Trained at Central School of Speech and Drama.

Theatre includes *Deathtrap* (Noël Coward Theatre), *Tosca* (New Diorama Theatre), *Less Than Kind* (Jermyn Street Theatre and National Tour), *Bewitched, Bothered and Bewildered*, *The Art of Concealment* and *Mother Adam* (Jermyn Street Theatre), *Play It Again Sam* (Upstairs at the Gatehouse) and *Antony and Cleopatra* (Central School of Speech and Drama).

Dan Pick | Assistant Director

At the Finborough Theatre, Dan is Resident Assistant Director at the Finborough Theatre as part of a placement through the MFA in Theatre Directing at Birkbeck, University of London and recetly assited on *Hindle Wakes* (2012).

Studied at University College London. Directing includes *Macbeth* (Bloomsbury Theatre), *God: A Comedy by Woody Allen* (Pleasance Dome, Edinburgh Festival) and *Brick* (Garage Theatre). Assistant Directing includes *Ovid's Metamorphosis* (Bristol Old Vic Theatre School). Film and Television includes *The Wolfman*, *House of the Rising Sun* and La Mermusic.

Esther Nissard | Producer

After producing for several years in France, Esther moved to London and graduated from the MA in Creative Producing for Theatre and Live Performance at Birkbeck, University of London. She has worked as Production Assistant for artist Bobby Baker on *Mad Meringue* (Liberty Festival, Southbank), as Theatre Manager at The Yard Theatre, Producer for Raising Silver Theatre (*The Firewatchers* at the Old Red Lion Theatre), Producer for Circles Theatrical Productions (*Circles* at five different venues including the Arcola Tent and the Tricycle Studio). She focuses her work on politically and socially engaged projects.

Luke Holbrook | Assistant Producer

Luke is Resident Assistant Producer at the Finborough Theatre where he has recently produced *Merrie England* (2012) and *Passing By* (2012). He was also General Manager for the critically-acclaimed New Writing Season (2011-12) which included *Foxfinder* and *Fog*. Forthcoming productions include *Somersaults* (2013).

Other theatre includes *London, 4 Corners: 1 Heart* (Theatre503), *A Woman Alone* (Brockley Jack Theatre) and *Ward No. 6* (Camden People's Theatre).

RK-Resource | Set Construction
Recent clients have included Chocolate Factory Productions, Ambassador Theatre Group, Sonia Friedman Productions, Novel Theatre Company, Theatre Royal Bath Productions, Little Night Music Limited and Headlong Theatre Company. www.rk-resourcekent.com

Tim Stark formed B29 Productions Ltd with Roy Smiles with the intention of producing provocative and challenging new writing and to develop work for younger and underrepresented audiences. Its productions include *Thick as Thieves* (Chelsea Theatre), *Signing Off*, *Bombing People* (Jermyn Street Theatre) and *Shadow Language* (Theatre 503). B29 also developed *Kurt & Sid* (Trafalgar Studios), the highest ever grossing and fastest selling Trafalgar Studio 2 production.

Production Acknowledgements
Identity Drama School www.identitydramaschool.com
Lighting Equipment supplied by National Theatre

Thanks to
The National Theatre Studio
Nick Hytner
Mark Dakin, Technical Manager, National Theatre
Matt Drury and Huw Llewellyn National Theatre Lighting Department
Charlotte Gwinner and all at Angle Theatre
Sean Campion
Paula Dionisotti
Matti Houghton
Amanda Lawrence
Penny Layden
Helena Lymbery
Antonia Thomas
David Warwick and the Arts Theatre

RVH
ROYAL VICTORIA HALL
FOUNDATION

FINBOROUGH | THEATRE

Winner – Eight awards at the OffWestEnd Awards 2012

"A theatre in a class of its own"
Time Out

"A disproportionately valuable component of the London theatre ecology. Its programme combines new writing and revivals, in selections intelligent and audacious." *Financial Times*

"A blazing beacon of intelligent endeavour, nurturing new writers while finding and reviving neglected curiosities from home and abroad." *The Daily Telegraph*

Founded in 1980, the multi-award-winning Finborough Theatre presents plays and music theatre, concentrated exclusively on new writing and genuine rediscoveries from the 19th and 20th centuries. We aim to offer a stimulating and inclusive programme, appealing to theatregoers of all ages and from a broad spectrum of the population. Behind the scenes, we continue to discover and develop a new generation of theatre makers – through our vibrant Literary team, our internship programme, our Resident Assistant Director Programme, and our partnership with the National Theatre Studio providing a bursary for Emerging Directors.

Despite remaining completely unsubsidised, the Finborough Theatre has an unparalleled track record of attracting the finest creative talent, as well as discovering new playwrights who go on to become leading voices in British theatre. Under Artistic Director Neil McPherson, it has discovered some of the UK's most exciting new playwrights including Laura

Wade, James Graham, Mike Bartlett, Sarah Grochala, Jack Thorne, Simon Vinnicombe, Alexandra Wood, Al Smith, Nicholas de Jongh and Anders Lustgarten.

Artists working at the theatre in the 1980s included Clive Barker, Rory Bremner, Nica Burns, Kathy Burke, Ken Campbell, Jane Horrocks and Claire Dowie. In the 1990s, the Finborough Theatre became known for new writing including Naomi Wallace's first play *The War Boys*; Rachel Weisz in David Farr's *Neville Southall's Washbag*; four plays by Anthony Neilson including *Penetrator* and *The Censor*, both of which transferred to the Royal Court Theatre; and new plays by Richard Bean, Lucinda Coxon, David Eldridge, Tony Marchant, Mark Ravenhill and Phil Willmott. New writing development included a number of works that went on to become modern classics including Mark Ravenhill's *Shopping and F***king*, Conor McPherson's *This Lime Tree Bower*, Naomi Wallace's *Slaughter City* and Martin McDonagh's *The Pillowman.*

Since 2000, new British plays have included Laura Wade's London debut *Young Emma*, commissioned for the Finborough Theatre; James Graham's *Albert's Boy* with Victor Spinetti; Sarah Grochala's *S27*; Peter Nichols' *Lingua Franca*, which transferred Off-Broadway; and West End transfers for Joy Wilkinson's *Fair*; Nicholas de Jongh's *Plague Over England*; and Jack Thorne's *Fanny and Faggot*. The late Miriam Karlin made her last stage appearance in *Many Roads to Paradise* in 2008. Many of the Finborough Theatre's new plays have been published and are on sale from our website.

UK premieres of foreign plays have included Brad Fraser's *Wolfboy*; Lanford Wilson's *Sympathetic Magic*; Larry Kramer's *The Destiny of Me*; Tennessee Williams' *Something Cloudy, Something Clear*; the English premiere of Robert McLellan's Scots language classic, *Jamie the Saxt*; and three West End transfers – Frank McGuinness' *Gates of Gold* with William Gaunt and John Bennett, Joe DiPietro's *F***ing Men* and Craig Higginson's *Dream of the Dog* with Dame Janet Suzman.

Rediscoveries of neglected work have included the first London revivals of Rolf Hochhuth's *Soldiers* and *The Representative*; both parts of Keith Dewhurst's *Lark Rise to Candleford*; *The Women's War*, an evening of original suffragette plays; *Etta Jenks* with Clarke Peters and Daniela Nardini; Noël Coward's first play, *The Rat Trap*; Charles Wood's *Jingo* with Susannah Harker; Emlyn Williams' *Accolade* with Aden Gillett and Graham Seed; and Lennox Robinson's *Drama at Inish* with Celia Imrie and Paul O'Grady.

Music Theatre has included the new (premieres from Grant Olding, Charles Miller, Michael John LaChuisa, Adam Guettel, Andrew Lippa and Adam Gwon's *Ordinary Days* which transferred to the West End) and the old (the UK premiere of Rodgers and Hammerstein's *State Fair* which also transferred to the West End, and the acclaimed Celebrating British Music Theatre series, reviving forgotten British musicals including *Gay's The Word* by Ivor Novello with Sophie-Louise Dann, Helena Blackman and Elizabeth Seal.

The Finborough Theatre won *The Stage* Fringe Theatre of the Year Award in 2011, won *London Theatre Reviews'* Empty Space Peter Brook Award in 2010, the Empty Space Peter Brook Award's Dan Crawford Pub Theatre Award in 2005 and 2008, the Empty Space Peter Brook Mark Marvin Award in 2004, four awards in the inaugural 2011 OffWestEnd Awards and swept the board with eight awards at the 2012 OffWestEnd Awards including Best Artistic Director and Best Director for the second year running. *Accolade* was named Best Fringe Show of 2011 by *Time Out*. It is the only unsubsidised theatre to be awarded the Pearson Playwriting Award bursary for writers Chris Lee in 2000, Laura Wade in 2005 for James Graham in 2006, for Al Smith in 2007, for Anders Lustgarten in 2009, Simon Vinnicombe in 2010 and Dawn King in 2011. Three bursary holders (Laura Wade, James Graham and Anders Lustgarten) have also won the Catherine Johnson Award for Pearson Best Play.

www.finboroughtheatre.co.uk

The Associate Director position is supported by The National Theatre Studio's Bursary for Emerging Directors, a partnership between the National Theatre Studio and the Finborough Theatre.

The Finborough Theatre has the support of the Pearson Playwrights' Scheme. Sponsored by Pearson PLC.

The Cameron Mackintosh Resident Composer Scheme is facilitated by Mercury Musical Developments and Musical Theatre Matters

The Finborough Theatre is a member of the Independent Theatre Council, Musical Theatre Network UK and The Earl's Court Society www.earlscourtsociety.org.uk

Mailing
Email admin@finboroughtheatre.co.uk or give your details to our Box Office staff to join our free email list. If you would like to be sent a free season leaflet every three months, just include your postal address and postcode.

Follow Us Online

 www.facebook.com/FinboroughTheatre
www.twitter.com/finborough

Feedback
We welcome your comments, complaints and suggestions. Write to Finborough Theatre, 118 Finborough Road, London SW10 9ED or email us at admin@finboroughtheatre.co.uk

Friends

The Finborough Theatre is a registered charity. We receive no public funding, and rely solely on the support of our audiences. Please do consider supporting us by becoming a member of our Friends of the Finborough Theatre scheme. There are four categories of Friends, each offering a wide range of benefits.

Brandon Thomas Friends – Bruce Cleave. David Day. Matthew Littleford. Sean W. Swalwell. Michael Rangos.

Richard Tauber Friends – Neil Dalrymple. Richard Jackson. M. Kramer. Harry MacAuslan. Brian Smith. Mike Lewendon.

William Terriss Friends – Leo and Janet Liebster. Peter Lobl. Bhags Sharma. Thurloe and Lyndhurst LLP. Jon Sedmak. Jan Topham.

Smoking is not permitted in the auditorium and the use of cameras and recording equipment is strictly prohibited

KHADIJA IS 18

Shamser Sinha

KHADIJA IS 18

OBERON BOOKS
LONDON

WWW.OBERONBOOKS.COM

First published in 2012 by Oberon Books Ltd
521 Caledonian Road, London N7 9RH
Tel: +44 (0) 20 7607 3637 / Fax: +44 (0) 20 7607 3629
e-mail: info@oberonbooks.com
www.oberonbooks.com

A catalogue record for this book is available from the British Library.

PB ISBN: 978-1-84943-488-1
E ISBN: 978-1-84943-664-9

Cover design by Cover design by Target Live

Printed, bound and converted
by CPI Group (UK) Ltd, Croydon, CR0 4YY.

For the sounds, stories, and lyrical invention of the apparently illiterate, immoral young people at the wrong end of money and the wars we fight.

Love to Charlie, Elsa and Khran. Big thanks to Tim 'the maestro' Stark for the caffeine-fuelled enthusiasm and support. A shout-out to Charlotte Gwinner, Bob Cant, Aisha Phoenix, Nic Wass, Rachel Taylor, Neil McPherson, Monica and Rodrigo. Vielen Dank zum Fahrradcafe und Dr Christian Struempell fuer seine schlechte Witze. Hello son. This is something your dad did. Baa baa boo!

Characters

KHADIJA

LIZA

ADE

SAM

JOANNA

There are five characters in this play. Khadija and Liza are two seventeen-year-old young women. They are separated young asylum seekers classified as 'unaccompanied' by the state. Khadija is from Afghanistan and Liza is from an unnamed Eastern European country. They have no family and are approaching their eighteenth birthdays when they will receive a decision on their residence claims. The other three characters are Ade (pronounced 'Addie'), Sam and Joanna. Ade is seventeen and moved from Leytonstone in East London to Hackney ten years ago. His parents are from Nigeria while Sam is an African Caribbean young man who is also seventeen and is born in Hackney. Joanna is in her mid-thirties and is from Ireland.

/ indicates overlapping dialogue

Khadija is 18 was first performed as a production without decor as part of the TriAngle season at the Hackney Empire on 21 June 2009. The play was performed by Shamaya Blake, Eric Kofi Abrefa, Jason Frederick, Olga Fedori and Megan Barnard.

SCENE ONE

KHADIJA and ADE are in ADE's bedroom. They are sitting on the bed. Their clothes and trainers are scattered on the floor. There is an open box of condoms on the bed, although KHADIJA and ADE are doing nothing sexual, because they've finished having sex.

ADE: Listen right, if I top up £50 on Orange yeah, I get £5 free credit.

KHADIJA: So. That's how they make money off you innit.

ADE: What d'you mean?

KHADIJA: 'Cos you don't know how much you're usin'. You just get 'appy. Finkin' like you got money. Then you burn up that credit fast boy.

ADE: Talkin' to you yeah.

KHADIJA: More like chattin' on wiv Sam.

ADE: No, I just get call waitin' these days, always got gal tings innit … 'A', you like my trainers? *(There are a pair of new brightly coloured Nike trainers lying on the floor.)*

KHADIJA: Mmm *(Nods head and makes non-verbal acknowledgement.)*

ADE: They're cool innit… Got 'em down JD's.

KHADIJA: When?

ADE: Yesterday. An' I bought this book man. *(Holds up Spiderman Graphic Novel.)*

KHADIJA: What? *(Laughing.)* Spiderman. *(Nods head.)* You wanna stop it wiv that you know.

ADE: Nah man, some of this stuff is sick, you get / me.

KHADIJA: Sick? It's a comic.

ADE: Truss' me, I got my eyes on this X-Men ting I seen innit.

KHADIJA: Mmm.

Beat.

Eh, you bring my book back?

ADE: No man it weren't in library. I checked yeah I wen –

KHADIJA: Yeah it is. They had it when I looked on computer.

ADE: I'm tellin' you I could not find it, you get me?

KHADIJA: Shutup.

ADE: It weren't there / when I went.

KHADIJA: Ade man that's slack… You probably didn't check good.

ADE: What? 'Course I did. Why didn't you go / library then?

KHADIJA: My coursework deadline is May 20. That's one week yeah.

ADE: You ain't even gonna do no homework tonight.

KHADIJA: So. I need it for tomorrow innit. Not everyone can jus' turn up and get A Star. How am I gonna go library yeah, when I'm busy down Centre?

ADE: What d'you mean? It's right by Town Hall.

Beat.

KHADIJA: What?… Town Hall… You gone Library down Hackney Central innit… *(Laughs.)* You fool man. *(Laughs.)*

ADE: What?

KHADIJA: I said College Library.

ADE: No you never.

KHADIJA: Yes I did.

ADE: No, don't / fink so.

KHADIJA: I'm *tellin'* you yeah. *(Laughs.)*

ADE: Did you?

KHADIJA nods and chuckles.

ADE: No… Wait up. *(KHADIJA chuckles.)*

KHADIJA: I was by Hackney Library this afternoon innit. You know I was goin' Centre.

ADE: Oh… Yeah… I thought it was strange you never got it.

KHADIJA: Why you so fool guy? *(Laughing.)*

ADE: *(Both laughing.)* Don't think I don't know you're gettin' joke off me.

KHADIJA: I texted you as well man sayin' pick it up.

ADE: So. I didn't get your text. Gym ain't got no reception. Anyways, how come you didn't get my text?

KHADIJA: I did.

ADE: I needed that tune back man.

KHADIJA: I was out of credit, innit.

ADE: More like you was doin' that Karate shit.

KHADIJA: Karate. *(Laughs.)* T'ai chi.

ADE: Mmm.

KHADIJA: It's good.

ADE: Is it tho'?

KHADIJA: I got problems with my tension *(Still laughing, ADE moves to massage her shoulders. KHADIJA shrugs him off.)* Oi. You know what yeah, that man can teach.

Beat.

And some of them boys in that class…are hot you know.

ADE: What! *(Fake anger – they both laugh.)* you bes' rest yourself.

They continue to get dressed.

KHADIJA: *(Singing Leona Lewis.)* 'Closed off from love / I didn't need the pain,' what? … 'I keep bleeding / keep keep bleedin, I keep / bleedin, keep keep bleedin – '

ADE: Oi, oi, oi.

ADE: Nah man. *(Kisses teeth.)*

ADE: 'A', 'A', shut up man. *(Decides to wrestle KHADIJA.)*

> *KHADIJA stops because she's chuckling and ADE continues to laugh.*

We need to shift yeah, my mum's back in 30 minutes.

KHADIJA: Don't lie. Ain't that late.

ADE: 2:30.

KHADIJA: Shit, I gotta go Centre…see my solicitor.

> *Pause.*

You fink if I win *X Factor* they let me stay? Leona Lewis is from Hackney, innit.

> *Beat.*

ADE: The Centre said your case is strong.

KHADIJA: Immigration took that new girl.

ADE: Who?

KHADIJA: That one livin' up Hackney Downs, innit. Put her in detention 'cos they said she's over 18… She was gonna join the Mums and Bumps group wiv Liza today yeah. You know how old the baby was yeah?

> *Beat.*

Two days.

> *Beat.*

> *(Kisses her teeth.)*

ADE: Khad –

KHADIJA: Home Office already said they ain't got my papers. I know they got sent yeah.

ADE: You got six months, six months 'til you're 18. That's enough time to sort it. You said they lose them papers all the time.

KHADIJA: Yeah…yeah. *(Goes quiet, pause.)*

ADE: Come on, you gotta go. I'll walk you down Centre.

KHADIJA: You don't have to.

ADE: I gotta get some food in for when my mum gets off shift before my drivin' lesson. …Truss me yeah! I been savin' for time to start these / lessons.

KHADIJA: You ain't even got money to buy car, so I don't know why you're goin' on like that.

ADE: Whatever.

Beat.

'A' 'A' 'A' can you take them condoms?

KHADIJA: Why? *(Smiles.)*

ADE: Why d'you fink? I don't want my mum finding them innit.

KHADIJA: What makes you fink you gettin' another go? You bes' jus' keep'em. *(Both laugh.)*

SCENE TWO

The scene takes place in the kitchen/dining area of sparsely decorated social services' accommodation where LIZA and KHADIJA live. KHADIJA is reading while LIZA is chopping vegetables and peeling potatoes.

Baby crying. LIZA gets up to go and settle her baby. But just as she gets up, her baby stops crying.

LIZA: Khadija. There is pasta in fridge. *(Yawns.)*

KHADIJA: I ain't hungry.

LIZA: But you cook food.

KHADIJA: Maybe I make it too much. You eat it. You like it. *(Smiles.)*

Pause.

You're lookin' sleepy.

LIZA: Ah, yes, but what I do? You tired too.

Beat.

29

You will see Ade tonight?

KHADIJA: He ain't rung.

LIZA: Why you not ring him?

KHADIJA: I told him, 'ring me this time, Thursday and we'll hook up'. Go *Batman* or

Shrugs shoulders as if she's not very bothered about whether he's called.

Probably he ain't finished drivin' lesson yet. I don't know you know, that boy has been doin' it for three month, I fink, innit…ain't even got no money for car, you get me?

LIZA: These boys, you have to see what they like, yes?

KHADIJA: He's studying really hard these times yeah.

LIZA: If this boy like you then he is ringing. They say ring but…

KHADIJA: I know you don't rate him.

LIZA: Not for me, but if I rate him is not important, worry… you stay safe isn't it?

KHADIJA: Yes!

LIZA: I tell you what these boys like, some not care, not ringing, 'are you OK? How you are?' just for sex. Make him use condom yes?

KHADIJA: It ain't like you never told me is it?

Beat.

LIZA: What happen other boy?

KHADIJA: Who?

LIZA: Doing your fighting…like Judo

KHADIJA: It ain't fightin'!

KHADIJA and then LIZA laugh.

It's T'ai chi. That ain't fightin'. *(Laughter.)* That was time ago. Like March. How comes you askin'?

LIZA: In college I see him. He look good.

KHADIJA: Let me tell you. I thought Ade liked me but really I fought that boy was hot innit.

LIZA: *(LIZA nods to indicate the boy is hot.)* mmmmmmm

KHADIJA: Believe. I tried to check 'im.

LIZA: But you get *blank*!

KHADIJA does a mock serious stare and then they both laugh.

KHADIJA: And then Ade was after me but I told him 'no'. And you know what right? Then Sam tried to chirps.

LIZA: Sam. Is it?

Beat.

KHADIJA: That's cheek tho' innit. Him and Ade are tight. How can you play your boy like that?… But you know what yeah, then I thought, Ade is alright you know. He ain't one of them stupid boys, yeah. You can talk to him.

Beat.

And I fink he likes me, you get me?… He got me these. *(Points to earrings.)*

LIZA: You are player.

KHADIJA: That's just it though. I ain't really.

Beat.

I didn't fink I would like Ade. But if I – I ain't even gonna lie yeah, it's not like I don't fink about like religion – but if I want to have sex then I'll do it… I mean for my mum yeah, I don't really fink she would have sex before my dad. She was well into her religion yeah. But I want what she had. How she love my dad.

Beat.

LIZA: Tomorrow for you is fasting, is Ramadan, no?

KHADIJA: Depends on moon innit.

LIZA: Month, isn't it, you not eating in day.

Beat.

Eat then.

KHADIJA: Nah, I don't really feel like it.

LIZA: You should eat.

KHADIJA: Oh my gosh!…one time yeah, my mum come back wiv my dad from Haj innit.

LIZA: Yes.

KHADIJA: when they go Mecca, Eid time. And they was in their room. On Haj, they couldn't sleep together. For a month they was separate in them ways yeah.

Beat.

I could *hear* them.

LIZA: *(Makes a yuck sound.)*

KHADIJA: That time they was *loud*! No word of a lie yeah, I had to stick my hands on my ears. And I couldn't sleep yeah…and all them looks…you know when they was makin' food. In the evening together or somefink. I knew they liked each other yeah. That's how I want it to be. You get me?

LIZA: Mmm *(Non-verbal acknowledgement.)*

KHADIJA: I hated hearing them then, you know, all night. But now.

Beat.

They was happy.

Pause.

What 'bout you? I know you like that boy down Centre.

LIZA: Boy. I not have time for boy. I have other problem.

KHADIJA: The way you walk man…like your bones is tense.

LIZA: If I'm not have some answer or something. I gonna be.
(Makes an angry, frustrated noise.)

KHADIJA: Innit. If they send me back…I don't know no one in
Afghanistan no more, you get me? Not no one.

LIZA: What did your solicitor say?

KHADIJA: Nuffink innit. Immigration still makin' out like they
ain't got my papers. Only got three month now yeah.

Baby starts crying.

KHADIJA: Maybe you should try Katrina with that other food?

LIZA: I dunno. Jus' feel funny. Wrong. Mum give me baby. Tell
me to look after, before she go, *(Points upwards to signify her
mum is dead.)* before I come London…but I not.

Pause.

KHADIJA: I know.

Beat.

LIZA: Everything is taking away. One day I have mum. I have
dad. I have sister. Next day is gone. Now…all this coming
on my head. *(Taps the top of her head with her hand to signify
pressure coming down on her.)* Sometime I dreaming they find
out Katrina is not mine, then what is happening.

Beat.

Immigration put us in camp. Send back. Everything gone
again.

KHADIJA's phone rings.

LIZA: Ade?

KHADIJA: No. 'Hello…You can…yeah, yeah, Tuesday it's
good… Yeah. Alright then. What time you want me?…
Alright then 5:00. Yeah OK… I'll be there.' *(KHADIJA puts
phone down.)*

LIZA: You want cigarette? I owe you.

Baby stops crying.

KHADIJA: No.

LIZA: No. What wrong with you?

KHADIJA: Just don't fancy it. *(Rubs her sore neck.)*

LIZA lights a cigarette.

LIZA: You need to see about neck. And you tell doctor not eating…what job this is?

KHADIJA: Cleaner, £3 an hour. Let me go see them and find out what it's about…I been to another GP again yesterday but *(Shrugs shoulders.)*

LIZA: Still they not take you?

KHADIJA: Can you rub my neck?

LIZA: My friend know someone for work. I know her too. Cleaning or something, but is in strip club, they do dancing, lap dancing. And they have private room. My friend just clean there. I work there for month. It's ok. They give £4 an hour.

KHADIJA: Where?

LIZA: Shoreditch.

KHADIJA: Cool. I mean. I need the money right. Gimme the number.

LIZA: Wait. I have on my phone. *(Flicks through her phone and passes it to KHADIJA. Baby starts to cry. KHADIJA keys the numbers into her phone. LIZA walks off to go and soothe baby.)*

SCENE THREE

ADE and his friend SAM are sitting in ADE's lounge playing Playstation.

ADE: *(Checks his mobile for messages.)* Yo Sam, this Grand Theft Auto is rubbish man. You need to put Liberty City in.

SAM: *(Puts Liberty City in.)* What's up wiv you?

ADE: Nuffin'.

SAM: What you lyin' for?

Beat.

You're gettin' blank off Khadija innit.

ADE: Tell the truth, I ain't really bothered. Whatever man, I'm easy.

Pause.

I was hopin' to sex her though. *(Both laugh.)*

ADE: Is it cool if I go round yours? My mum's back from shift later.

SAM: No man, my mum is there. Anyway Khadija ain't even rung you.

ADE: So, I have to go park then? You got condoms?

SAM: Not on me. You bes' get shines. I told you link it and leave it. She's a skank man. Like that Liza wiv her benefits baby.

Beat.

Kotch wiv us lot tonight innit? Might go up Wood Green. There's *bare girl* up there you get me.

ADE: I'll see… It's just sex man. I'm playin' her innit.

SAM: Is it?

ADE: I don't feel no way yeah.

SAM: Why you keep checkin your messages then?

ADE: Why you think? My boys innit.

SAM: *(SAM kisses teeth.)* Boys? You ain't got no boys.

ADE: Carry on, carry on.

SAM: You been linkin' that girl since you started drivin' lesson blood. She's a ref man. She ain't even chung really.

ADE: Like I said I ain't really –

SAM: That girl finks she's Beyonce truss me? Do your tings and gone… I don't know why you're goin on like it's all wifey.

ADE: Yeah yeah / chat on.

SAM: Why she's even living in that place when she can get council house you know, 'ref'.

Pause.

'A', you wanna watch out, yeah. She'll probably get pregnant.

ADE: I ain't gettin' catch like that.

SAM: You'll have to pay that child support shit man. Watch an' see.

ADE: Nah man, nah, I ain't goin' out like that.

SAM: You're gonna turn marga.

ADE: What?

SAM: You won't even have no money for food, gal, nuttin' *(SAM and then ADE laugh.)* Yo, you wanna play Pro Evo?

ADE: Alright then. You want revenge from last time innit.

SAM: Revenge? Revenge? How many times I beat you, bruv?

ADE: Still beat you last time tho'.

SAM: I was Saudi Arabia man.

ADE: So.

SAM: Saudi Arabia! How is that gonna beat all Brazil an' ting.

ADE: Excuses man. Excuses.

SAM: Excu – , do you know what, put it in,

ADE: You / sure.

SAM: Put it in.

ADE: Is it tho'?

SAM: Come. What you waitin for blood?

ADE: Alright then, let's do it.

ADE turns round behind him. SAM gets his mobile phone out to send a text. ADE can't see SAM.

ADE: Where? Where is it man?

SAM: I don't know. Look. It's your house, innit. *(Oblivious to ADE, SAM continues to text. He sends the text. ADE's mobile buzzes. ADE turns round sharply to get his phone. He opens it up expectantly to check his messages. SAM starts laughing.)*

ADE: Yeah, yeah. You're funny.

SAM: See how you jump when you think it's your gal, innit.

ADE: Joker. I'm gonna beat you big time now man.

SAM: Uh-huh. Come on then. Truss me I ain't gonna be Saudi Arabia this time.

ADE: Is it?

SAM: Mmm.

ADE bends down to put the game in the Playstation.

ADE: You workin' Saturday?

SAM: Yeah, I think so. Depends on my shifts. Gotta buy some decks innit.

Doorbell rings. KHADIJA walks in.

ADE: *(To KHADIJA.)* What you sayin' man?

KHADIJA: I thought we were hookin' up tonight. *Batman.*

SAM: *(To ADE.)* Ade, I'm done yeah. I need to go. Call me after innit.

ADE: *(To SAM.)* You just don't wanna get beat.

SAM: *(To ADE.)* Next time bruv, next time.

Beat.

Actually, I need a piss first.

SAM gets up to leave room. He and KHADIJA briefly exchange looks. SAM exits the stage.

ADE: We are babes. I just been wiv my boys.

KHADIJA: You ain't got no boys.

ADE: What you being like that for?

KHADIJA: You only friend is Sam.

ADE: That's cold man! I been missin' you. I been wantin' to see you.

KHADIJA: Well you better see me tonight otherwise you'll be wantin' for a while.

Beat.

ADE: Why?

Beat.

Ramadan.

KHADIJA: Mmm. *(Non-verbal acknowledgement.)*

We hear SAM's footsteps coming down the stairs.

SAM: Ring me later innit. *(Bowls towards the door.)* I need to beat you on that game star.

ADE: You ain't beatin nuttin'.

SAM: Whatever. Laters.

ADE nods. SAM exits stage.

KHADIJA: Sam man. That guy's a dick. You need to / sort it out.

ADE: So we linkin' up then?

KHADIJA: 6:00 by the Lido at London Fields?

ADE: Alright then. But what you doin' now?

KHADIJA: I gotta go chill wiv Liza first innit. She's gettin' lonely these times.

ADE: Mmm. *(Nods a non-verbal acknowledgement.)*

KHADIJA: Getting vex about how she can't go down Centre.

ADE: She stressin' you?

KHADIJA: Babysittin'. She on at me for that.

ADE: Is it?

KHADIJA: It ain't that bad, ain't that bad…it's hard for her, you get me?

Beat.

Stressin' me out 'bout you tho' *(They both laugh.)* 'how come he ain't rung', 'why don't he come by', whatever. *(Both laugh.)* Anyways, I need to go.

ADE: 'A', is you friend on register tonight?

KHADIJA: Nah man. But I can get us in free anyways innit.

ADE: Is it? How comes?

KHADIJA: Check this, check this yeah. It's easy. You know them man who take the tickets yeah.

ADE: Mmm.

KHADIJA: About 10 minutes before the next film showin' yeah, on any of the screen, one of them goes on toilet check and the other two, they go in the cinema and make sure everyone is gone from there. Then they gotta clean it.

ADE: Yeah

KHADIJA: Mmm. Quick clean though. Only like five minute… so who you fink is checkin' ticket?

Beat.

ADE: No one.

KHADIJA: You get me innit guy!

Beat.

So then you go in any of the cinema. Watch like about 15 minute of some dry film when they cleanin' where you wanna go. Then…when it's like your time for the film.

Exit. By that time, them guys are back on ticket duty, they ain't gonna see nuffink /. Go in the other cinema. Watch *Batman* innit.

ADE: Is it?

ADE: Alright then, cool, cool.

KHADIJA: Innit tho'! Me and Liza done it 'nuff times yeah, that place got like five screen, you just gotta wait 'round. Watched like two film last time for freeness, yeah.

ADE: How come you never / done it wiv me?

KHADIJA: Plus I know someone for free popcorn an' drink.

ADE: *(Laughs.)* But what about me tho'?

KHADIJA: You don't even like goin' cinema. You're only goin *Batman* 'cos you like that comic book shit. *(ADE laughs.)* But that Liza yeah, she love it up, she love up that Bollywood man.

ADE: Alright, cool, cool yeah.

KHADIJA: Eh, I gotta get goin'. *(KHADIJA gives ADE a peck on the cheek and turns to leave.)*

ADE: Heh Khadija

Beat.

KHADIJA: What? *(Turns round.)*

Pause.

ADE: Nothing. See you there, yeah.

KHADIJA: *(Giggles.)* Me too.

They both laugh.

KHADIJA: Bye.

ADE: Later.

SCENE FOUR

LIZA and KHADIJA's accommodation. KHADIJA is doing her make-up. LIZA is taking wet clothes out of a bag and putting them on a washing stand.

KHADIJA: Katrina's quiet. You get her to sleep?

LIZA: Yes. At moment.

 Beat.

 What time you meeting Ade?

KHADIJA: 6:00.

LIZA: Don't be late tonight.

 Beat.

 And don't be late tomorrow. Always late. You know what time I am at Centre.

KHADIJA: Tomorrow? I fought –

LIZA: What?

KHADIJA: I fought it was Thursday.

LIZA: I tell you yesterday!

KHADIJA: Babes, shit, sorry! I can't do it.

LIZA: But you say. Why this is? I need to go Centre. Who is going to sit with Katrina?

KHADIJA: I can't –

LIZA: It is for language class.

KHADIJA: I can't –

LIZA: We cooking dinner everyone.

KHADIJA: I can't though. I gotta go mosque.

LIZA: Why you not say?

KHADIJA: I dunno. Probably…are you sure you said Wednesday?

LIZA: Yes!

Pause.

KHADIJA: Liza…thing is…it's first day fasting tomorrow. I
want to break it wiv the mosque people. I just –

LIZA: What?

KHADIJA: Sorry babes.

Beat.

Maybe I got mix up somefink.

LIZA: Mixed up? You not thinking. I tell you, look what you
are doing.

KHADIJA: I –

LIZA: Today again you forgetting. This is why I go launderette.
Now the clothes wet. You know it close at 5. Last dry 4:30.

KHADIJA: Li / za.

LIZA: And Katrina is ill today.

Beat.

Never looking.

Pause.

Is not first time Khadija, not first time.

Beat.

KHADIJA: Liza, you know jus'

Beat.

a lot goin' on, you get me?

Pause.

LIZA: Look it OK

Pause.

I know this fasting is important.

KHADIJA: It is.

LIZA: This thing is good for you. Mosque people is…

KHADIJA: I feel bad.

LIZA: It's OK, it's OK. Go.

Beat.

KHADIJA: I know you like goin' Centre for English.

LIZA: Yes, I need to know for me, for my baby…so I can learn. It not like the college. They laugh at me in the college.

KHADIJA: Fuck them man!

LIZA: In lunch hall laughing, say food in my country is not good. They not wanting to sit next to me. And lesson. I can't understand.

KHADIJA: Maths? You good at maths tho'.

LIZA: Yes. Is numbers isn't it? I can do. But talking is problem. I mean… I can…but sometimes they laughing say I am 'ref', I just come for my baby, for sitting in council house.

KHADIJA: Leave them innit.

LIZA: They not want us here. The way I speak, they make fun, they wanna bang. You know they gonna make problem.

KHADIJA: Come on babes.

LIZA: But it's OK for you. You speaking good English. Because wiv Katrina. I cannot get out. Only college and Centre. Sometimes Centre.

Beat.

You are making friends. You can understand. You speak good. There is many thing I not understand, many thing.

KHADIJA: You know a lot man. When I come yeah, I knew nuffink without you. Half my clothes was stinkin 'cos I was too scared for washing them 'til you said how. The others too small. Shrunk. I still don't understand that launderette you know.

LIZA: Yes. I know this. *(LIZA is hanging wet clothes on the washing stand, and wrings one item to show it's still wet before placing on stand.)*

They both laugh.

KHADIJA: Look I gotta get ready.

LIZA: This place…is not home. I want to stay, but is not home.

Beat.

But it's OK when you are here, feel maybe it's OK here.

KHADIJA: I ain't goin' nowhere.

LIZA: You don't know that.

KHADIJA: No. *(Said quietly.)*

Pause.

LIZA: Already maybe I think thing is different now.

KHADIJA: How? I jus' been busy and –

LIZA: With Ade.

KHADIJA: Yes. But that don't mean you ain't my girl.

Pause.

Heh, look, I'll break my fast here tomorrow yeah.

LIZA: But –

KHADIJA: I ain't looked after Katrina for a bit.

LIZA: But the / mosque.

KHADIJA: I said man. It's alright. I go next day innit…go your class. You need to get out.

Phone rings.

It's Ade. I bes' get goin'.

SCENE FIVE

This scene takes place by the entrance to the Lido at London Fields. ADE and KHADIJA are waiting for SAM.

SAM enters.

ADE: Sam man. You're late again. Why you always late?

SAM: Fam, it ain't my fault.

ADE: Yeah / yeah.

SAM: Shutup.

ADE: Bring that tune.

SAM: / Yeah.

KHADIJA: I got places to go Sam, you get me?

SAM: *(To KHADIJA.)* Like where? Nailbar?

ADE: *(To KHADIJA.)* Film don't start 'til 8:00.

SAM: *(To ADE.)* I had to pick my mum up from the bus stop after work.

ADE: Blood, it's only 6:00. It ain't even dark. What you / stressin' for?

SAM: It ain't that. It ain't that. My mum's worried bruv. She seen dem yoot on the estate. The new ones, they ain't even like proper black yeah. I don't even know what's goin on wiv them.

ADE: Where they from?

SAM: I dunno, sound something like Arabic, sound to me anyway. Maybe like Somalia, Sudan or somefink, I dunno. But since they come yeah, my mum's friend yeah, from the church, was tellin' her about how they try and start fight.

ADE: Is it?

SAM: Mmm, you / know, hang 'round / the stairwell two floor down from my / mum, givin' attitude, like they run it or somefink.

KHADIJA: *(To ADE.)* Oi, oi.

ADE: *(To KHADIJA.)* Wait!

KHADIJA: *(To ADE.)* Hurry up man.

ADE: That old guy got robbed down there innit.

SAM: Exactly, nowadays people gettin' bang. Not just that old guy you know.

ADE: It's / true man.

SAM: And my mum is worried yeah.

ADE: It ain't safe.

SAM: Innit tho'. I don't know how comes they gettin' council house.

ADE: You lot been waitin' for *time* / guy.

SAM: I was born these ends bruv. Wherever they're from yeah, I don't know yeah, all I see, is the man is makin' beef and the woman is makin' baby.

ADE laughs.

Ching, ching, council house, you get me,

ADE is still laughing.

(Incredulous.) Some of dem new gal is slack yeah, oh / my gosh.

KHADIJA: Shutup man.

SAM: What?

ADE: *(To KHADIJA.)* Eh, Khadija.

SAM: *(To KHADIJA.)* 'A', you know it's / true yeah.

ADE: *(To SAM.)* You go work / today?

KHADJA: Bare shit / man, truss me.

SAM: *(To ADE, ignoring KHADIJA.)* Don't let me have to start yeah, nah man. I need to get out of that job star.

ADE: You goin' up Wood Green still?

SAM: Yeah. Linkin' up at chicken shop innit.

Beat.

ADE: That girl you like yeah? *(Laughs.)* Look she might not even be up there guy. You bes' off jus' callin' her. Go round her yard.

SAM: You must be mad!

ADE: Why?

SAM: I ain't goin down there. Her mum don't like me. *(ADE laughs.)* Church girl innit. Let me tell you something yeah, when you go church every Sunday you see them yeah, all dressin' nicely prayin' an' ting.

ADE: Mmm. *(Non-verbal appreciation of fine-looking women.)*

SAM: Mmm, but I guarantee you, some of those church girls are out there, you know. And their parents don't like none of it you get me? *(SAM and ADE crack up with laughter.)*

KHADIJA: *(To SAM, interrupting the laughter.)* Well, you're a player anyway. If you like a girl, how you gonna talk about her like that?

SAM: *(To KHADIJA.)* Like what. I'm just goin' about my business. If it was a sket, I wouldn't care but…it's up to me /, I decide whether I want to talk about it or not… I ain't sayin' I'm goin' round tellin' everybody yeah, I'm tellin' Ade / and my crew.

KHADIJA: *(To SAM.)* Whatever.

KHADIJA: *(To SAM.)* Why you chattin' on about it then?

SAM: *(To KHADIJA.)* So what am I meant to do? Ask the girl who can I tell that I sexed her?

And she goes, 'no', I'm not meant to tell no one yeah?

KHADIJA: *(To SAM.)* Then your crew will tell next man and they tell other people. Why you have to go on like that? You're just playin' girls. / You're just a player.

SAM: *(To KHADIJA.)* Who plays girls? Who / plays girls?

KHADIJA: *(To ADE.)* O my days man! How can he say he don't play girls when he grins like that?

ADE: *(To KHADIJA.)* He's jus' vexin' you innit.

SAM: *(To KHADIJA.)* I could know nuff girl and have their digits right, but that ain't playin' girls, that's just knowin' girls and havin their number.

KHADIJA: *(To ADE.)* What? I don't know what kind of lyrics / he chattin' now.

SAM: Wait up, wait up, if I'm goin' out with this girl I'm not goin' out with no other girl. I don't play girls.

KHADIJA: Yeah, is it? Is it tho'?

Pause.

SAM: Maybe I flirt with girls / when I'm goin' out with a girl but I don't play them.

KHADIJA: C'mon guy, come on, nah.

SAM: Anyway, some of you girls are players too.

KHADIJA: What you sayin' man?

SAM: Jus' some of you girls are players innit. *(As he says this he dials some digits on his phone.)*

Silence.

'Yo man, you there yet…yeah, yeah, chill, I'm comin' / innit, I'm comin now'.

KHADIJA: *(To ADE.)* Come on. We gotta go.

SAM: *(To ADE.)* You comin' Wood Green? Come up Wood Green / n'man.

KHADIJA: *(To ADE.)* I thought we was goin' *Batman* innit.

KHADIJA: *(To SAM.)* Get us in free, yeah.

SAM: Is it?

KHADIJA: *(To SAM.)* Yeah. Not your / boys tho'.

ADE: *(To KHADIJA.)* 'A', 'A' babes, we can chill up Wood Green, yeah.

KHADIJA: *(To ADE.)* I don't even like them / up Wood Green, you get me?

ADE: *(To KHADIJA.)* Allow it man!

SAM: *(To ADE.)* Why she bein' / like that for?

KHADIJA: *(To SAM.)* I swear to god yeah…what makes you fink I wanna watch you try and chirps some butters gal.

KHADIJA: *(Talking to ADE.)* Wood Green? Chicken shop? Nah man. Oi, truss me yeah.

Pause. She's about to kick off.

ADE: *(To SAM.)* I already said I was goin' *Batman* innit.

SAM: Cool / blood, I'm only sayin'. Ain't no thing.

KHADIJA: *(To ADE.)* Wasteman.

ADE: *(To SAM.)* Alright then.

SAM: 'A', my boys are gonna screw, yeah, I'll check you at college.

ADE: Laters.

SAM exits stage.

KHADIJA: I don't know what you're stylin' it for like 'A A babes'.

ADE: I ain't stylin' nuttin. That's just how I speak, innit.

KHADIJA: *(Kisses her teeth.)* An' chicken shop? What!

ADE: Wood Green was jus' an idea.

KHADIJA: Yeah, a rubbish one, why you even friends wiv him for?

ADE: Oi, me and 'im are tight yeah. He was cool when I first come / here from Leytonstone.

KHADIJA: Cool, he's a dick, guy. You know how he talks about girls yeah.

Even girls he likes. An' I know what he finks 'bout Liza, yeah.

ADE: Liza? He didn't say nuttin 'bout Liza.

KHADIJA: Why's he's chattin' on 'bout baby an' council house then?

ADE: But did he mention her tho'?

KHADIJA: Why's he chattin' on then? / I'm tellin' you guy. Who you think he's talkin' 'bout?

ADE: Did he mention her?

KHADIJA: I don't live in no council house. Liza don't live in no council house neither /. It's hard yeah. It ain't like what he's chattin' /. My hostel ain't like no council house, you get me?

ADE: I ain't sayin' that.

ADE: I ain't sayin'.

ADE: I ain't…it's just, …it's tough for him wiv his mum needin' / a new flat.

KHADIJA: Why you makin' excuse for? / I know how he talks about 'ref'.

ADE: Excuse?

ADE: His bro' can't even breathe proper cos of the damp in that flat, yeah.

KHADIJA: I never made it damp.

ADE: He ain't got nuttin' against no one, you get me?

Beat.

What you fink he sees right?, like his mum is working hard. That's truesay. Then you got some next girl come in, ain't workin', nuttin', gettin' benefits, / while his mum is doin' double shift.

KHADIJA: Liza ain't gettin' much benefits yeah. It ain't –

ADE: She been here one year before you. One year before you I seen her at college.

KHADIJA: So.

ADE: Look how she's talkin' and look how you talkin'.

KHADIJA: She got baby man. Why you think she's always vex 'bout babysittin'? 'Cos she wanna go English class. You lot givin' joke 'bout her at college.

ADE: That ain't me.

KHADIJA: 'A', shutup / yeah,

ADE: Is that me tho'?

KHADIJA: I seen what them boys like / yeah.

ADE: It don't look right. If you have baby, something, next thing you're gettin' council flat.

KHADIJA: Does it look like Liza got council flat?

ADE: Still paid for. Some girls are clever yeah, truss me, they know how to get that benefit.

KHADIJA kisses her teeth.

ADE: All I'm sayin' / is you know some girl.

KHADIJA: Liza ain't no sket yeah, you think you / know shit.

ADE: I ain't sayin' that /. Come on man.

KHADIJA: You think you know shit, you need to jus' hush up guy.

ADE: Why?

KHADIJA: Liza ain't no sket yeah.

ADE: I jus' know what I seen.

KHADIJA: Well you ain't seen shit.

ADE: How comes she's gotta baby?

KHADIJA: How come?

ADE: Yeah, how comes / she's gotta baby?

KHADIJA: How come? Shut up / man.

ADE: She ain't even 18.

KHADIJA: Ade, you're / chattin shit.

ADE: What you sayin'!

KHADIJA: Shut up.

ADE: What you sayin'! What you / sayin'!

KHADIJA: It ain't even hers!

ADE: Wha –

 Pause.

KHADIJA: Prick man.

ADE: What you mean? What you / talkin' about?

KHADIJA: What you fink? It ain't even hers.

ADE: How come she got it then?

KHADIJA: They're sisters.

ADE: Sis…nah man.

KHADIJA: She had to bring Katrina here when she come, 'cos their mum was gone.

ADE: Why?

KHADIJA: Shutup. Like I'm tellin' you. Sket. *(Said quietly, nods head.)* She had to look after the baby.Done. What all them boys an' Sam fink' yeah, they can jus' get the fuck out, you get me?

 Pause. ADE moves to grab her arm but she pulls away slightly.

KHADIJA: Move from me man. Don't be sayin' nuffink to Sam an' shit.

ADE: I ain't gonna / do that.

KHADIJA: You best jus' shut up 'bout it yeah.

ADE: What you care what he / thinks anyway?

KHADIJA: You get me?

ADE: Told you, I ain't sayin' nuttin'

KHADIJA: Ain't sayin' nuttin'. *(Speaking to herself.)* He's your bredren innit, why you fink I'm bothered what he finks?… that girl works hard I'm tellin' you, it ain't no council house business yeah…it ain't good if that shit / gets out.

ADE: I ain't gonna tell no one.

Beat.

Don't worry 'bout Sam, what he's sayin'.

Beat.

I like you that's all you need to worry about…

Beat.

'though I always worry 'bout you.

Pause.

KHADIJA: Do you?

ADE: Yes!

KHADIJA: Well, you ain't gonna see me much 'til after Ramadan, so I don't know why you wanted to chill up Wood Green.

Pause.

What you gonna do now you worry 'bout me?

ADE: What d'you mean?

KHADIJA: I dunno… Jus' you and me… I dunno. It can't go on like this. I ain't goin' back yeah. I'm finkin'…I might…I might have to run away.

Beat.

ADE: I know.

KHADIJA: Is it? You know. How comes?

ADE: Just 'cos…I got some money…but… at the end of the day yeah, what kind of life is that?, you / get me?

KHADIJA: Would you come?

ADE: Dunno. Look your people said you might win anyway.

KHADIJA: Might!… I don't want to leave you and Liza.

Pause.

What kind of trainers would you buy then? *(Laughs quietly.)*

ADE: What d'you mean man?

Beat.

Don't cuss my trainers. Nah, that's wrong man.

KHADIJA: That's the first thing I thought about you.

ADE: What?

KHADIJA: How dry your trainers was man.

ADE: Even them Nike I bought? You said you liked my trainers.

KHADIJA: No, you go on about them. I just go 'mmm'.

ADE: So, how comes –

KHADIJA: What?

ADE: How comes you tried to check me?

KHADIJA: I don't fink so! I seen you at college. But…then I was down the road from the mosque. I know what you done. I know you liked me yeah and you said to your friends, to tell me, but they didn't tell me, they told my girls, 'oh he likes your friend yeah'… That's how it happened. You couldn't even chirps me yourself yeah. *(Laughs.)*

ADE: You think you're funny innit. I know you liked me. That's why you got your friends to check me out tho'.

KHADIJA: Nah man / you liked me for a whole month yeah before you done anyfink. I had to pass you my number through my friends. You couldn't even come / up to me. Liza thought you was lame. So I tried to style it out with her yeah like, 'I ain't really bothered by him, yeah. You get me?'

ADE: Don't try and make out like you was cool.

ADE: Oi, shutup yeah.

ADE: Yeah *(Laughs.)* But you caused me 'nuff trouble, 'nuff trouble, you know.

KHADIJA: What you on 'bout?

ADE: Leavin' the condom packet in my bedroom yeah, the first time innit. *(They both laugh.)* I told you *take it*! *(Laughing.)*

KHADIJA: You got catched. *(Laughing.)*

ADE: My mum was screwin' yeah. She screwed hard, 'As if I didn't know. Don't bother with lyin' you are having sex aren't you'. 'No.' 'Yes you are having sex, I know you are!!'. Then she gave me some hot speech, innit. I was like, boy, this is two years too late, you get me?

Laughs.

KHADIJA: But you were good wiv me, yeah. You know I never done it much before… And them earrings and that. I knew that you liked me and I could talk to you… I liked makin' love wiv you…lots.

ADE: Liked.

KHADIJA: Like.

SCENE SIX

This scene takes place in the common room at college. As the scene begins LIZA and KHADIJA are sitting together on one side of the room doing their homework. SAM is on the other side of the room.

LIZA: Heh, Khadija after Ramadan – is two weeks now yes?

KHADIJA: Yeah.

LIZA: There is new film. Sharukh Khan. *(LIZA strikes a Bollywood dance pose, KHADIJA and LIZA laugh.)*

KHADIJA: Cool.

LIZA: We go, yes?

KHADIJA nods. ADE enters.

ADE: Waagowaaan *(SAM is half-noticing the exchange from the other side of the room.)*

KHADIJA: Mmm.

ADE: What you sayin'?

ADE bends down to give KHADIJA a peck on the cheek. She turns slightly away as she is slightly cold.

KHADIJA: Jus', you know, got coursework innit.

ADE: You wanna listen to some tunes I mixed at Sam's yard?

KHADIJA: Not really. *(ADE shrugs like he's not bothered.)* I got things to do yeah. Gotta hand this in by 3.

ADE: Alright then.

ADE walks over to where SAM is sitting.

SAM: Oi.

ADE: What?

SAM: Tonight yeah, we can't be doin' tunes round mine yeah.

ADE: Is it? Why?

SAM: The boys ill innit.

ADE: Ill?

SAM: Somefink wiv his breathing again…doctor said he needs to go hospital.

ADE: Shit man.

SAM: I know. That flat ain't helpin' yeah. Those walls are wet, blood.

Scene shifts back over to LIZA and KHADIJA.

LIZA: This assignment teacher give today. I don't understand.

KHADIJA: Why?

LIZA: Because they are just making game on you… I don't like it.

SAM starts playing a tune on his phone on the other side of the common room. SAM and ADE start dancing. ADE is taking this dancing particularly seriously.

KHADIJA: What is it?

LIZA: English, they just giving you question so you think, 'yes I know nothing'. This question, all these sentence, have 'there'…but you choose which one to put in.

KHADIJA: 'A', what you on about?

LIZA: I mean –

KHADIJA: Pass it. What?

Beat.

…O…you gotta fill in the sentence.

LIZA: Yes! I know this!

KHADIJA: You have to put 'there' in the sentence.

LIZA: I just say this! But there is more than one there, e-i-r and e-r-e. Which one it is? I dunno. For you it's OK. You know /. Can you say?

KHADIJA: Me?

KHADIJA: I don't get nuffink about writing sister. Nuffink. Speakin', it's OK, but like when it's all writing... Ask Ade. He's good at English man. *(KHADIJA and LIZA look at ADE dancing.)* That boy's always readin'.

LIZA: Ade?...you think he help?

KHADIJA: 'Course innit, just ask.

LIZA: But maybe he's laughing.

KHADIJA: Ask him.

Scene shifts back to SAM and ADE dancing to the music on SAM's phone.

SAM: We need to get on it wiv these tunes yeah. We're gonna have to go round yours innit.

ADE: Nah man. My mum's gonna be in.

SAM: Allow it blood. We gotta finish that mix by tomorrow.

Beat.

You got a better plan.

LIZA: Ade! *(Calls from other side of the room.)*

Music stops.

ADE: What?

LIZA: I have problem.

ADE: So

The boys laugh.

KHADIJA: Ade!

LIZA: I, with English... You help me?

ADE: What?

LIZA: This assignment. They wanting to know what word you putting in. It is 't-h-e-r-e or t-h-e-

ADE: Just bring it, innit... *(LIZA is unsure.)* bring it.

LIZA walks gingerly toward ADE and SAM. She shows ADE the assignment.

LIZA: Because this / question.

ADE: *(Raises a hand.)* Wait, wait. Let me read it, yeah.

Pause.

What you gotta do right, is like there are two ways of saying 'there'.

LIZA: I know this! But what it is I dunno. Why is one word is two thing?

ADE: 'Their ball is lost'. That is e-i-r. 'Put the ball over there' is e-r-e.

LIZA: Why is difference?

ADE: Like, it's difficult… Look right, when you say 't-h-e-i-r', it's like when it belongs to them. So, here right, 'their ball is lost', why…because the ball belongs to them, innit. But here, 'put the ball over there' is 'e-r-e', because, it ain't about who owns the ball. Right?

LIZA: But someone, this ball / is for someone.

ADE: But it ain't about them, it's about putting the ball over there.

LIZA: Why?

ADE: It just is, right?

SAM: Why you talkin' to her?

LIZA turns to SAM and gives him a dismissive stare. SAM starts playing music from his phone again.

ADE: It gives you examples in the book, innit. Thing is –

LIZA: What this is?

ADE: What?

LIZA: I know this.

ADE: What?

LIZA: Can I hear?

ADE: *(To LIZA.)* Alright

ADE: *(To SAM.)* 'A' Yo!

SAM, dismissive, turns the music up. KHADIJA and SAM are observing. ADE begins to dance, SAM bobs head and LIZA begins dancing too for a few seconds.

LIZA: It is good. Ghetts, no?

ADE stops dancing.

ADE: Uh-uh. Uh-uh. Don't sound like Ghetts! Kano, innit.

SAM turns the music off.

LIZA: Yes. You liking this music. Like Grime or something I think.

ADE: How come Khadija never help you?

LIZA: I ask her. She dunno nothing. Even college like maths she not know *anything.* So she don't know what money is lot. I always saying 'you can't buy this' or 'why you spend money on this' when not even pay phone credit.

KHADIJA: Oi! Easy man.

ADE: It's true tho'.

KHADIJA: I ain't that bad.

Beat.

LIZA: *(To KHADIJA.)* Khadija. Where is your earrings?

KHADIJA: *(To both.)* I jus' took them out before gym yesterday.

LIZA: *(To KHADIJA.)* You like this? *(Shows KHADIJA her new earrings and necklace.)*

KHADIJA: *(To LIZA.)* Yeah, I told you, you already show me when you got 'em.

LIZA: *(To KHADIJA.)* But this is with another clothes.

LIZA: *(To ADE.)* Is good?

ADE: *(To LIZA. Smiles.)* It's cool.

KHADIJA: *(To ADE.)* I gotta go finish this homework, yeah.

ADE: *(To KHADIJA.)* Check you later, yeah?

KHADIJA nods, she and LIZA exit.

SCENE SEVEN

College common room.

LIZA: Ade, you going Business Study?

ADE: Cancelled innit.

LIZA: He not even good teacher, no?

ADE: It's Business Studies. I dunno why I'm doin' it… You seen Khadija?

LIZA: She is leaving for lesson one hour before. You know this. Where is Sam?

ADE: Why does everyone ask me 'bout Sam? I don't go everywhere wiv him you know.

Beat.

Why you even talkin' to me today? You just don't wanna look bad in front of Khadija innit.

LIZA: No, Ade is not true.

ADE: You don't even like me.

LIZA: Is not good not talkin'.

ADE: It weren't me that stopped.

Beat.

LIZA: Maybe we can be something like friend.

ADE: Look, you started to par yeah.

LIZA: No you not ring. Why you not ringing?

ADE: What?

LIZA: So, this not good. You jus' playing, like these other boys, jus' lookin sex.

ADE: I ain't playin' nuffin'. That's time ago / anyway yeah.

LIZA: Why you not ring me? I ring you and I tell you ring me this day.

ADE: So?

LIZA: You did not. And then you do it *again* with me. Two time. If you like me, if we have something, you ring me this day…I know what it is you like, you check me but link other girl. Just doing everything like is Sam.

ADE: I weren't linkin' no one them times. Anyway yeah, I did ring you, 'come link me yeah', innit. You never had no time, man.

Beat.

You got baby anyway and you always studyin'.

LIZA: Yes. I work! Because when my baby grow up and she gonna ask me something, and I say, 'I don't know it', it's not good, so I have to learn for the…to answer anything to my baby. So, what is wrong with that?

ADE: Nuffink…but it's vexin you inside, yeah.

LIZA: What?

Beat.

ADE: Khadija's sayin' man. You / takin' it out on her.

LIZA: What she is sayin'?

ADE: Everytime we meetin', you gettin' vex cos you can't get out.

LIZA: Me. Oh my days! This girl.

ADE: I know, I know how you never rated me. You been cussin' me down innit. I know how you speakin' against / me man.

LIZA: Is not true.

ADE: Jus' vex up 'cos you ain't gettin' no babysittin. / Can't go Centre.

LIZA: You know nothing!

ADE: Lookin' after a baby, I ain't sayin' that's easy but.

Beat.

Ain't like it's Khadija's fault is it? Screwin', 'cos you can't get out.

LIZA: Is not true.

ADE: I know / you been runnin' me down wiv her.

LIZA: Is not true Ade! Is not true!

ADE: Why she gone all mood-face then? Why you wanna stop it wiv me an' her? She can't be / babysittin' for you all them times. You need to stop running your mouth and stop chattin shit 'bout our / business yeah.

LIZA: You know nothing!

LIZA: I doing everything for this girl since she is coming, *everything*! Before you, you / are even, even knowing her!

ADE: You just bitter man. You understand?

LIZA: What?

ADE: Cos the baby ain't yours innit.

LIZA: What you mean?

ADE: You know.

LIZA: She tellin' you.

ADE: Your baby ain't her problem, yeah.

Pause.

LIZA: What you mean? What you saying? Khadija tell you?

ADE: It ain't even your baby. You're jus' vex, stuck in your yard.

LIZA: You keeping shut.

Beat.

not telling Sam, anyone.

ADE: I aint tell –

LIZA: You just shutting mouth. Helping her so much. When she come here this country. She know nothing. You shutting your mouth of this.

ADE: She need time away too.

LIZA: Time away? *(Slower.)* What you think she do with time away?

Beat.

You, Sam, other, say I am dirty, ref, skank, say I have baby for council / house.

ADE: I ain't sayin' that.

LIZA: I never wanting this baby. I stay in hostel with other 'unaccompanied'. The wall is not dry. It is not good for keeping well. It is dirty with mouse.

ADE: I never said / that tho'.

LIZA: I am not skank. Now,

Beat.

you have sex with Khadija. What it is? *(Said calmly with poison.)*

Beat.

Sam saying she is good sex?

Beat.

ADE: What, what you sayin' man?

LIZA: You know this

Beat.

no?

Beat.

Before you are with her. She think / I dunno.

ADE: What you lyin' for?

LIZA: Lying? Why you think they not talkin' now?

ADE: That ain't right, that ain't right. Me and Sam are tight yeah. Like he ain't tellin' me.

Why you lyin'?

LIZA: Not lie

ADE: You just think like…you need her yeah, 'cos you ain't got nothing. How can you play your girl like that?

LIZA: Khadija. Khadija. Do not worry…Khadija. For this girl I am doing many thing.

ADE: Nah man. That's rude. You're playin' her. I thought you and her was tight.

LIZA: She just thinking herself. Just keep her happy. Not care me, anyone. I

Beat.

I

ADE: Nah man.

LIZA: I not want to sit in lonely. I thinking you. I am young woman you understand.

ADE: Mother.

LIZA: So?

ADE: You dumped me. You did not even like me.

LIZA: Is not true.

ADE: You're just worried 'bout being sent back. You / think if you have a baby here, they won't send you back after your birthday.

LIZA: Is not true Ade!

ADE: That's why you ain't usin' condom.

LIZA: No! That was mistake. Girls not go out, buy condom, we not putting on. You did not have condom...I can't believe you think I want baby with you to stay. That is what your boys, your Sam is saying.

Beat.

I thinkin' of you Ade.

Pause.

You not seeing her much? What you think she do with her time? Where she is working? *(Said calmly and with poison.)*

ADE: Cleanin' job, innit.

LIZA: Not cleanin'. She selling it.

ADE: What?

LIZA: She working club in Shoreditch.

ADE: That ain't true.

LIZA: She is prostit / ute. She go with anyone.

ADE: That's ain't true. That's lies.

LIZA: Lies, yes? She need money, you know it. Where you think she get money?

ADE: Social innit.

LIZA: No.

ADE: It ain't true.

LIZA: How come you not see her out of college?

ADE: It's Ramadan.

LIZA: It got nothing to do with this.

SCENE EIGHT

At the college gates.

KHADIJA: You seen Ade?

LIZA: No.

KHADIJA: I tried to call him.

LIZA: I not see him.

KHADIJA: Liza

LIZA: What?… What is it?

KHADIJA: I…I found some blood.

LIZA: Blood? What, / Where?

KHADIJA: I'm bleedin'…you know… It feel…dirty babes…
don't smell right.

Beat.

LIZA: What you talking? Period, no?

KHADIJA: It ain't period. It ain't that. I had one two week ago,
before I seen Ade.

LIZA: So, I mean, maybe…you not eating.

KHADIJA: I'm regular tho'. Always regular. It don't feel right.

Beat.

LIZA: You use condom, like I / say you.

KHADIJA: Yes!

Beat.

But not from start. Last time Ade put it on after / we was
already doin' it.

LIZA: I tell you! O my days! What you doin'? My days. You go
hospital? / Why you not tell me?

KHADIJA: I try that innit. They say I gotta register GP first!

LIZA: You go social worker, yes? *(Command, not question.)*

KHADIJA: Friday

Beat.

I need to find Ade.

LIZA: I worry now. This Ade is making thing bad for you.

KHADIJA: Liza. It ain't like that, you get me? I'm / tellin' you.

LIZA: Yes? Then why there is blood. Why he not come yesterday? You waiting. He not even call.

KHADIJA: What use is blankin' him?

Beat.

I need to tell him 'bout the bleedin' but –

LIZA: Why you go to him? Who is here? I am.

KHADIJA: I know. I know Liza. You're my girl. But jus'...I don't know it helps...

LIZA: He not keep you safe. You think Ade can stop blood?

Beat.

You know they don't like us here.

KHADIJA: But –

LIZA: Just think!

KHADIJA: OK I will.

Beat.

But I... I'm seein' him tonight.

LIZA: That not good idea. You not see him.

KHADIJA: Why?

LIZA: Just not. You stop it.

KHADIJA: If I wanna see him. I see him that's it! Yeah.

LIZA: No.

Beat.

KHADIJA: I'll fink about everything you said. OK babes?

Beat.

But I gotta see him. I'm gonna see him.

SCENE NINE

ADE sees KHADIJA at his house. They're on the doorstep.

KHADIJA: I need / to talk Ade.

ADE: I know where you been working.

KHADIJA: What?

ADE: An' about Sam.

KHADIJA: Sam.

ADE: Don't lie to me. Liza told me yeah. He said you was a skank.

KHADIJA: What you chattin 'bout? I / ain't no skank.

ADE: Why you lyin'?

KHADIJA: I ain't lyin.

ADE: Liza said you was a prostitute…some club in Shoreditch.

KHADIJA: I'm a cleaner / there.

ADE: Rank man.

KHADIJA: Who you callin' rank?

ADE: She told me you –

KHADIJA: Why you gonna believe her?

Beat.

ADE: When was you seein' Sam?

KHADIJA: Sam…why?

ADE: When?

KHADIJA: Does it matter? Before I started seein' you.

ADE: Nah / man.

KHADIJA: And the job. Liza got me the job, yeah.

Beat.

I clean. A maid. I just keep shit clean and sort rooms.

ADE: I don't believe that. / What you think this is?

KHADIJA: What's it to you anyway? I gotta keep it together man. The money from social is small, you get me?

ADE: I can't believe you did that. / How come you done it?

KHADIJA: Did what? I told you. I'm jus' a maid there. It's alright for you, yeah. You can just go out, get any job, whatever.

ADE: Nah / man.

KHADIJA: But I'm a *ref*.

Beat.

Like your boy. Sam says.

Beat.

ADE: Nah, this –

KHADIJA: How much social you fink I get?

Beat.

I don't work legal. I can clean or I can sell it. Other girls have sex for money. What they gonna do?

ADE: You done it, innit.

KHADIJA: No! My time is comin' yeah. What I'm gonna do if they try and send me back? I ain't goin' back, I'm tellin' you, yeah. Everyone I know…dead, missin'. You gonna save me?

ADE: I told you.

Beat.

We was gonna fink of something. / Your case is still goin' on.

KHADIJA: I can't wait for finkin. What you gonna do?

Beat.

You fink Spider Man is gonna turn up? It ain't no comic guy. Two month! Two month! Ade. My visa is done. I got / to sort myself.

ADE: I can't take this. I need to think. I –

KHADIJA: I ain't even gonna get no benefits. What I'm gonna do?

ADE: I need to think.

SCENE TEN

LIZA returns home. She walks to the front of the stage. She finds a letter on the floor. She opens the envelope up and reads the letter. We hear KHADIJA's voice reading out the letter. KHADIJA is on the stage with her bags. She is packing her stuff into sportswear bags.

'It got too much Liza. I had to go. The Home Office was still tryin' to say they ain't got my papers. I can't jus' wait for them to come an' take me. It ain't right cuttin' other girls behind their back. It ain't right. But I know what you like and what you done for me. I missed you these two months. Without you I was lost. When I come this country, it was like I fall out of sky. I didn't even know it was London. I come out of truck. And I start to speak, someone in the street say, "you are in England". He speak my language, Dari. So I don't know where I am, I don't know nothing. But you tell me everything. Thank you.

Pause.

Go on wiv your life now. Look after Katrina. I love you. Tell Ade I love him too. Khadija.'

SCENE ELEVEN

This scene takes place at ADE's house. Doorbell sounds. SAM arrives.

ADE: What?... What d'you want man?

SAM: Ade, yeah.

ADE: Straight up guy you need to go.

SAM: An' you need to hear this.

ADE: I don't need to hear shit.

SAM: Look blood –

ADE: Blood?

Beat.

I ain't your bredren,

SAM: Khadija…Khadija is down Homerton Hospital.

ADE: What?

SAM: She gone –

ADE: What 'appen?

SAM: I don't know. All I know is she's gonna be OK.

ADE: What 'appen man?

SAM: I don't know what 'appen! Liza rung me, innit. She jus' said Khadija's down there and she had to go.

ADE: She must have said something. How come she there? You must / know something, man.

SAM: Ade. I don't know. I don't know man. Liza couldn't talk. She said she can't use phone in hospital, that's, that's what she told me.

Beat.

You need to get cab yeah, 'cos she says you got an hour before no more visitors.

ADE: How comes you want me to see her now, man?

SAM: *(Kisses his teeth.)* Just ring the taxi.

(SAM takes out his own phone, rings the taxi.)

It's ringing.

SAM hands phone to ADE.

ADE: Taxi…Homerton Hospital… Yeah…Burlington Court…
No.10…Ade. Alright then.

SAM takes phone back begins to walk out.

ADE: How come Liza rung you anyway?

SAM: 'Cos your phone is brockup guy!… She tried ringin' you.
Half the time it don't even work. I had to come down your
yard bruv.

Beat.

Man, why you lookin' at me all vex? Me and Khadija was
done time yeah, January, you get me? So stop your chattin'
innit.

ADE: Why didn't you tell me about you an' her?

SAM: Past is past bruv.

ADE: Eh, c'mon guy

Beat.

SAM: What good is this doing yeah?

Beat.

What d'you want me to say?

Beat.

Uh? What d'you want me to tell you? When you was
checkin' her, we was done. Now truesay you like this girl
yeah –

ADE: What's it to you?

SAM: 'A','A', you love that girl up man. 'Nah man, I'm just
sexin' her'. I heard them lyrics bare time yeah. That's lies
man. Khadija stopped it wiv me. I mean I ain't sayin' I was
in love wiv her but she didn't want me.

Beat.

but you're feelin' this girl yeah, like it's wifey or somefink. I mean I ain't got no girl that way. So, you bes' not fuck it up, 'cos I know you, I know you yeah and you like this girl.

ADE: This is fucked. Fucked.

SAM: You ain't gonna find out about her here, is it?

We hear the sound of the taxi beeping outside. ADE grabs his jacket and moves to door.

SCENE TWELVE

This scene is in hospital.

KHADIJA is sitting up on a hospital bed and LIZA is at her bedside.

LIZA: You are OK now?

KHADIJA: I've lost the baby.

LIZA: I know. The woman at social service. The good one. She tell me. She say you are here but you are safe.

Beat.

So, finally you get doctor.

KHADIJA: *(Laughs.)* My tits were sore and I was bloated. Not eatin'. I thought it was infection. And the bleedin'... I didn't fink.

LIZA: And you...you not lookin' good that time.

Pause.

Where you go?

KHADIJA: Your friend who gave me job. She knew a house where I could stay.

LIZA: She said she not see you.

Beat.

Did you?

KHADIJA: No. But I know you tell Ade I already done that.

Beat.

No, they say I just 'av to clean.

LIZA: But what happen? Social service woman said someone find you on street.

KHADIJA: Your friend put me out innit. She said I'm illegal. So it's not good for them. So, I said 'cool I go'.

LIZA: Where did you stay?

KHADIJA: I said. The street innit! You know, I never had no doctor, yeah, so I gone hospital. They said not emergency go doctor. So then I was back on street.

Beat.

I had pain. My stomach, *(Adjusts herself.)* my stomach was painin'. A woman see me, innit? She take me hospital, to Emergency. That's it.

LIZA: What woman?

KHADIJA: Dunno. Stranger.

LIZA: And Ade is dad?

KHADIJA: Yes!

Beat.

'A', I know you been goin' on wiv' im like I'm loose yeah but. *(KHADIJA is trying to stop herself being angry.)*

Pause.

LIZA: I'm sorry –

KHADIJA: Does he know I'm here? Don't tell him about the baby. Ain't no point now.

Beat.

LIZA: He…

KHADIJA: What?

LIZA: He already know.

KHADIJA is visibly saddened.

KHADIJA: How?

LIZA: I tell him.

KHADIJA: Fuckin' prick man. Don't you ever keep your mouth shut!

Beat.

Fuck.

Pause.

Is he comin' here?

LIZA: He is in canteen. He want to see you. I tell him 'wait outside' until I say.

Beat.

I get him?

KHADIJA: Yeah OK. If he's there. Then I need to see him alone.

LIZA: OK.

KHADIJA: Wait, yeah.

Beat.

Do you love Ade? If you love him then why did / you dump him?

LIZA: No, not in that way. I find it hard when I sit at home because I not have friends…I think it not easy to make friend here, England. It is different for you Khadija. You not have to sit in with baby. You speaking good English. I want someone who care for me. When I worry, is not good

KHADIJA: But you had me.

LIZA: And then, if you go? Everyone go.

Beat.

KHADIJA: You have Katrina.

LIZA: She is not mine. I love her yes, but…it is sister, I am not meant to have her like mother, maybe…I want something for me.

Beat.

I not looking good these days. Not eating, sleeping. Now I am like you.

KHADIJA: Thanks.

They both smile.

LIZA: Thinking maybe a boyfriend is good, no?

Beat.

KHADIJA: I know. I know it's hard for you babes. I know…I gotta rest soon. But I'll tell you how to make that pasta if you come tomorrow, yeah.

LIZA: Yes. I come.

JOANNA enters. She is a nurse.

JOANNA: Hello Khadila, is it?

KHADIJA: Khadija.

JOANNA: Sorry. Khadija. Can I talk to you alone for a moment?

KHADIJA: Liza. Gimme a minute, yeah.

JOANNA: Could you wait outside please?

LIZA: *(To JOANNA.)* Why?

KHADIJA: *(To LIZA.)* Go. It's OK.

LIZA hesitates and then leaves.

JOANNA: *(Dispassionately.)* I've got some news. Sophie McGregor from social services is outside with some people from Immigration.

KHADIJA: My God! Oh my God! My God, no!

JOANNA: We're going to release you from our care because you're better now.

KHADIJA: Not now. Please no, not now. / Please.

JOANNA: I'm sorry Khadija. I've got to do this.

KHADIJA: Why? Stop them. I don't want them to take me.

JOANNA: I can't do that. We tried to stop it. The Immigration people say we have to release you / to them.

KHADIJA: No!

JOANNA: Apparently you ran away once and they say you are at risk of doing it again.

KHADIJA: Just say I'm ill.

JOANNA: The doctors and everyone have seen your records. I can't get away / with it.

KHADIJA: Stop them.

JOANNA: You're an illegal now, the doctor said. You're over 18 and your visa has run out. We can't treat you now / that you're not an emergency.

KHADIJA: Ya Allah! Ya All – *(KHADIJA breaks down.)*

JOANNA: We have to release you. It's the law.

KHADIJA: No! If they take, if they take me…they will put me in the prison. In the detention. Then they will send me back to Afghanistan. People die there. They rape my mother. / They kill my mother.

JOANNA: I can –

KHADIJA: My father is gone. They take his head in front of me. I don't want to die. No! No!… My boyfriend is outside. I want to see him. *(KHADIJA moves to get up but JOANNA places a light hand on her shoulder.)*

JOANNA: I'm sorry. They've stopped your visitors now.

KHADIJA: He's outside!

JOANNA: I don't know what I can do. I –

KHADIJA: He's in / the corridor.

JOANNA: There is nothing I can do! *(Speaking slowly, loudly, insistently and calmly.)*

Pause.

KHADIJA: I just want to see –

JOANNA: *(Glances at watch.)* They won't let him come in now dear. I need to confirm these details. What is your full name?

KHADIJA: What? What / is this?… Why?

JOANNA: For our release records. What was your name, dear?

KHADIJA: Er…Khadija Ahmad.

JOANNA: And how old are you?

KHADIJA: 18.

End.

WWW.OBERONBOOKS.COM

Follow us on www.twitter.com/@oberonbooks
& www.facebook.com/oberonbook